people in

art

National
Gallery

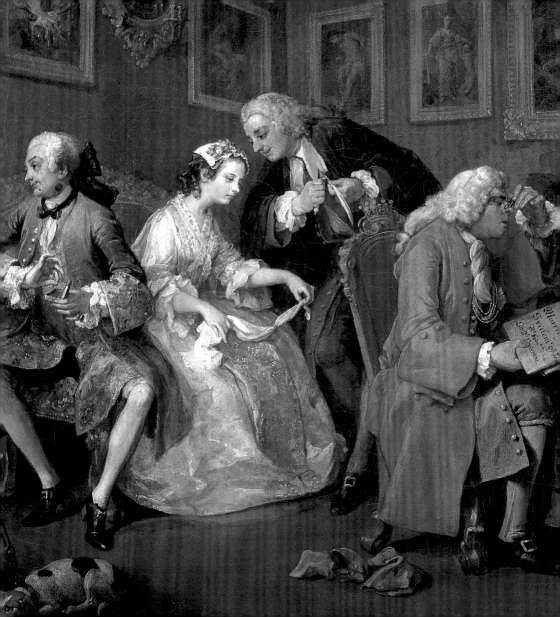

people in

art

National
Gallery

Jacques-Louis David: detail of *Portrait of the Vicomtesse Vilain XIIII and her Daughter*

Copyright © 1998 MQ Publications, Ltd.

All illustrations reproduced courtesy of the
Trustees of the National Gallery, London.

First published in the United States in 1998 by
Watson-Guptill Publications, Inc.
a division of BPI Communications, Inc.
1515 Broadway
New York, NY 10036

Series Editor: Ljiljana Ortolja-Baird
Designer: Bet Ayer

Library of Congress Catalog Card Number: 98-85851

ISBN: 0-8230-0335-3

First published in the United Kingdom in 1998 by
MQ Publications Ltd.
254–258 Goswell Road
London EC1V 7EB

Printed and bound in Italy

1 2 3 4 5 6 7 8 / 05 04 03 02 01 00 99 98

Title page: William Hogarth, detail of *Marriage À-la-Mode: I,
The Marriage Contract*

Ferdinand Bol: detail of *An Astronomer*

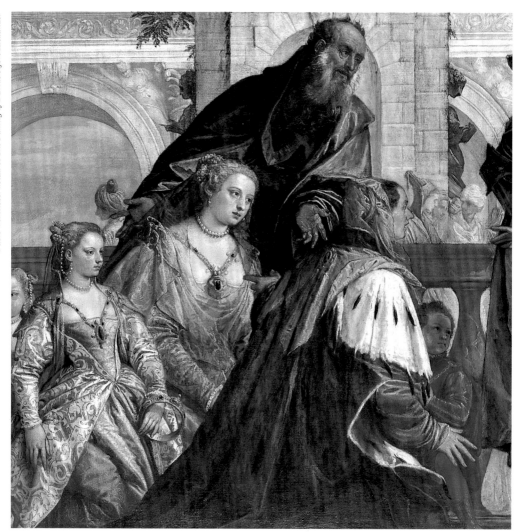

INTRODUCTION

'As painting, so poetry'. Like all siblings, the Sister Arts are rivals and allies. In the mirrors they hold up to nature, we see the world reflected from varying angles and by different lights.

The National Gallery in London houses many of the finest European paintings in existence; in most of them, human figures take pride of place. Through portraits of the famous, languorous mythological fantasies, the pathos of religious imagery and glimpses of everyday lives of men, women and children, painting records universal human ideals, failings and feelings. And it is these which in turn shape the words of poetry and prose.

By exploring each painting in detail, sometimes discovering aspects that we never 'knew' were there and by juxtaposing text and image in witty and often unexpected yet apt combinations, *People in Art* encourages us to enter the perennial sisterly debate concerning the topic nearest and dearest to us – ourselves – and simultaneously to hone our responses to both art and literature.

Erika Langmuir
Head of Education, National Gallery, 1988–1995

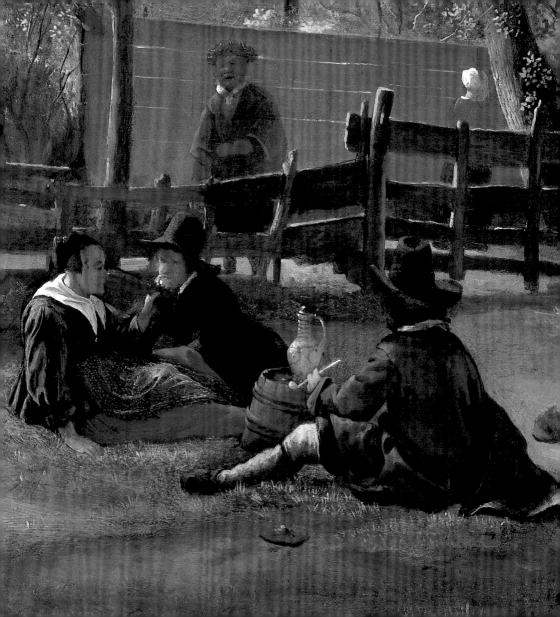

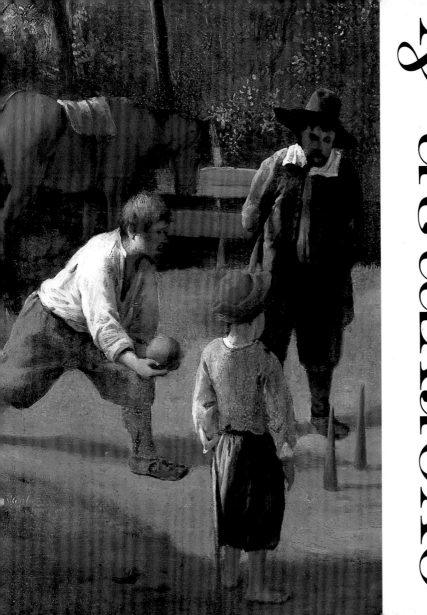

everyman & everywoman

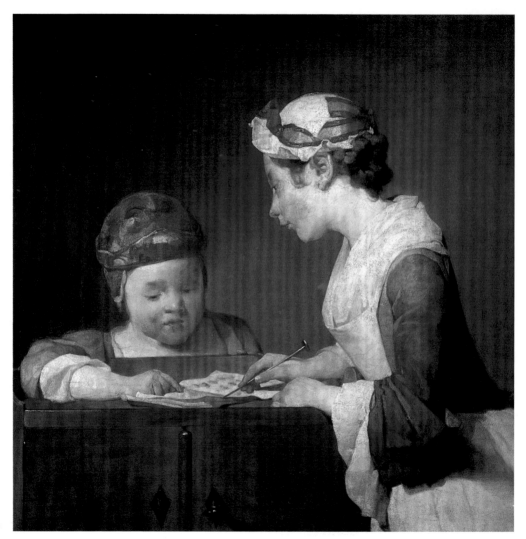

JEAN-SIMÉON CHARDIN (1699–1779) French
The Young Schoolmistress
probably 1735–36

I learnt the collects and the catechism,
The creeds, from Athanasius back to Nice,
The Articles, the Tracts *against* the times
(By no means Buonaventure's 'Prick of Love'),
And various popular synopses of
Inhuman doctrines never taught by John,
Because she liked instructed piety.
I learnt my complement of classic French
(Kept pure of Balzac and neologism)
And German also, since she liked a range
Of liberal education, – tongues, not books.
I learned a little algebra, a little
Of the mathematics, – brushed with extreme flounce
The circle of the sciences, because
She misliked women who are frivolous.
I learnt the royal genealogies
Of Oviedo, the internal laws
Of the Burmese empire, – by how many feet
Mount Chimborazo outsoars Teneriffe,
What navigable river joins itself
To Lara, and what census of the year five
Was taken at Klagenfurt, – because she liked
A general insight into useful facts.

I learnt much music, – such as would have been
As quite impossible in Johnson's day
As still it might be wished – fine sleights of hand
And unimagined fingering, shuffling off
The hearer's soul through hurricanes of notes
To a noisy Tophet; and I drew…costumes
From French engravings, nereids neatly draped
(With smirks of simmering godship): I washed in
Landscapes from nature (rather say, washed out).
I danced the polka and Cellarius,
Spun glass, stuffed birds, and modelled flowers in wax,
Because she liked accomplishments in girls.

'An Englishwoman's Education' from *Aurora Leigh*,
ELIZABETH BARRETT BROWNING, 1857

13

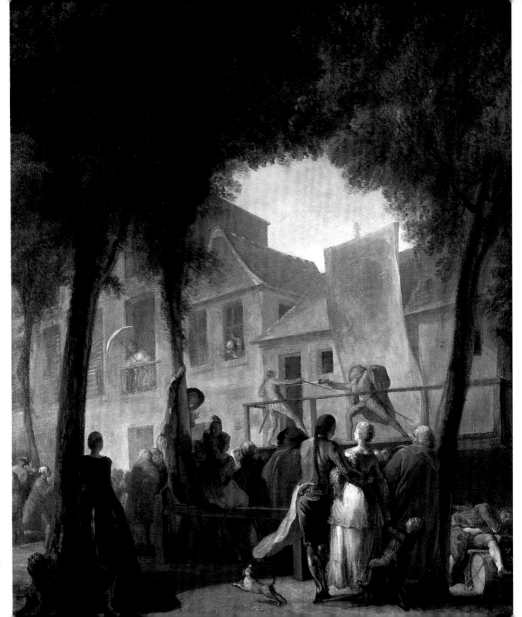

14

GABRIEL-JACQUES DE SAINT-AUBIN (1724–1780)
French
A Street Show in Paris
1760

The Parisian is never indifferent to what goes on around
him, and the slightest new thing will stay his steps. A man
has but to direct his gaze upwards and appear to observe
something attentively and you will see others stop to look
also. The crowd gathers and everyone is asking what there is
to be seen…Street performers and quacks draw an audience
at the first motion, though it melts away as quickly as it
forms. I believe that there is nothing easier than to arouse or
incite the Parisian populace, but very little seems to disperse
them; and the wandering crowd in the street is made up
chiefly from the outskirts, of people little familiar with their
surroundings, or those who like to waste their employer's
time. Examine any group; out of a hundred there will be
forty servants and nearly as many apprentices.

from *The Picture of Paris*,
LOUIS SEBASTIAN MERCIER, 1788

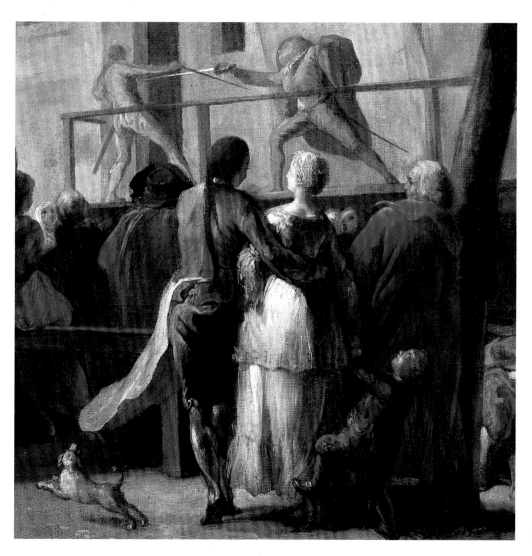

FERDINAND BOL (1616–1680) Dutch
An Astronomer
1652

When I heard the learn'd astronomer,
When the proofs, the figures, were ranged in columns
 before me,
When I was shown the charts and diagrams, to add,
 divide, and measure them,
When I sitting heard the astronomer where he lectured with
 much applause in the lecture-room,
How soon unaccountable I became tired and sick,
Till rising and gliding out I wander'd off by myself,
In the mystical moist night-air, and from time to time,
Look'd up in perfect silence at the stars.

<div align="right">

When I Heard the Learn'd Astronomer,
WALT WHITMAN, 1865

</div>

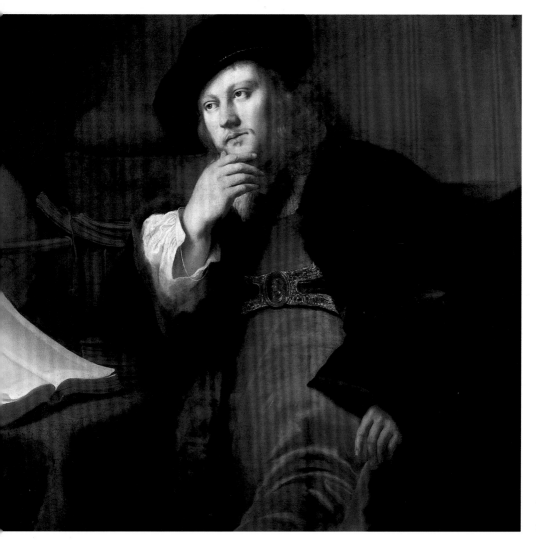

20

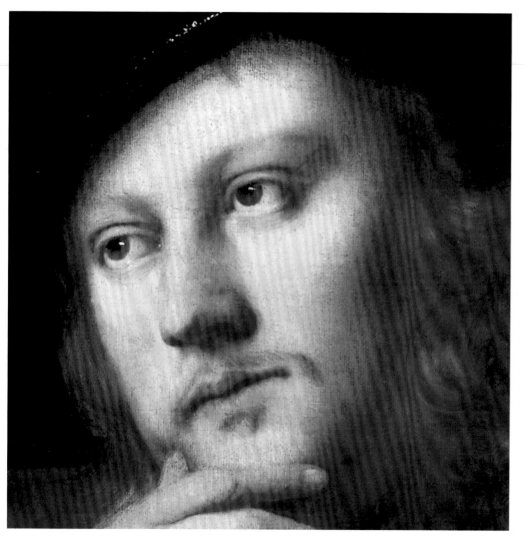

21

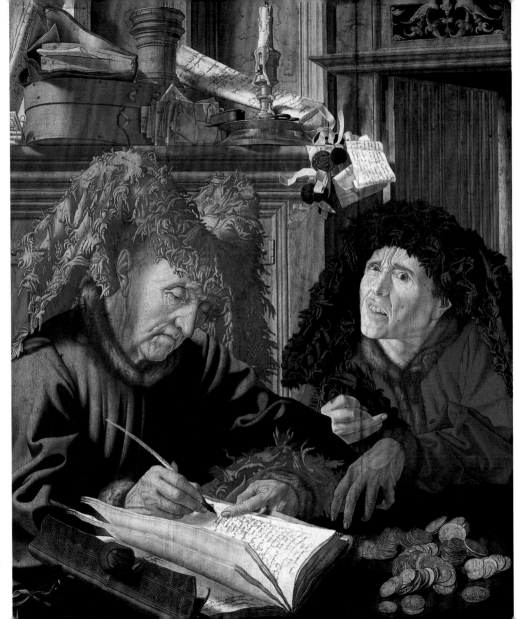

MARINUS VAN REYMERSWAELE
(active 1509?; died after 1567?) Netherlandish
Two Tax Gatherers
probably about 1540

(*King Richard to Bagot and Green, his servants*)
We will ourself in person to this war;
And, for our coffers with too great a court
And liberal largess are grown somewhat light,
We are enforced to farm our royal realm;
The revenue whereof shall furnish us
For our affairs in hand. If that come short
Our substitutes at home shall have blank charters
Whereto, when they shall know what men are rich,
They shall subscribe them for large sums of gold
And send them after to supply our wants.

from *King Richard II*,
WILLIAM SHAKESPEARE, 1595

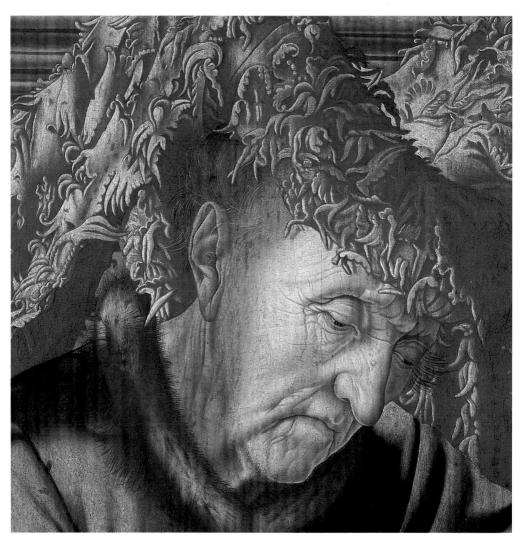

24

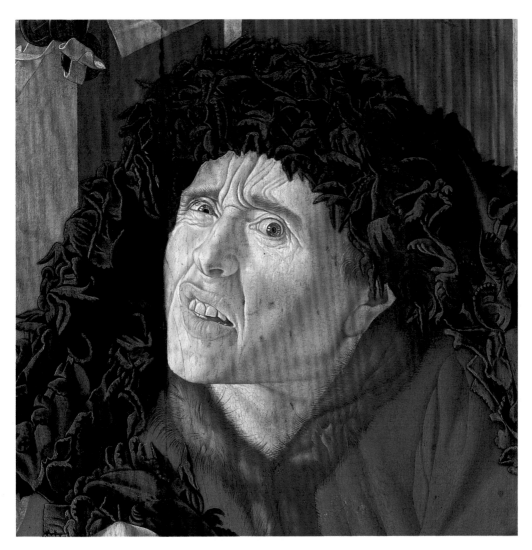

PAUL CÉZANNE (1839–1906) French
An Old Woman with a Rosary
probably 1896

On the platform appeared a frightened-looking little old
woman who seemed to shrivel inside her poor clothes. She
had large wooden clogs on her feet and a large blue apron
round her hips. Her thin face surrounded by a cap without a
border was more crossed with wrinkles than a shrivelled
pippin, and two long knotted hands emerged from the sleeves
of her red jacket. They were so encrusted, roughened and
hardened with the dust of barns, with washing and the
grease of sheep's wool that they seemed dirty even though
they had been rinsed in clean water; from so much use they
remained half-clenched, as though to offer their humble
witness to so much endurance. A sort of fixed rigidity gave a
kind of dignity to her expression. No sadness or tenderness
softened that pale stare. In the company of animals she had
taken on their dumb placidity.

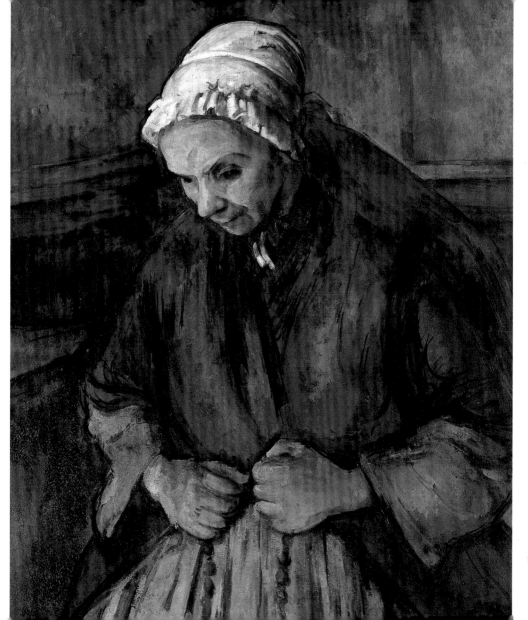

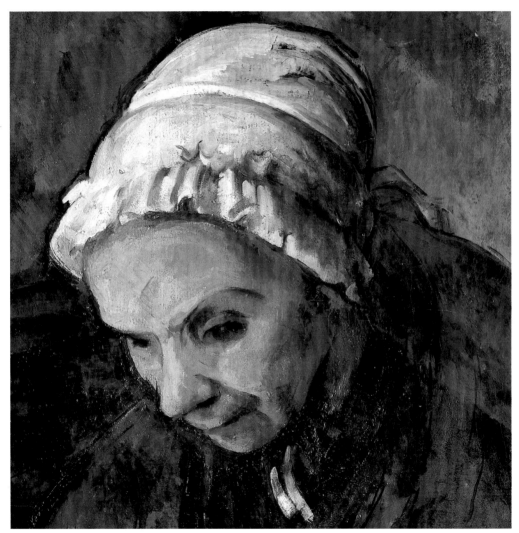

Inwardly frightened by the flags and the drums, by the gentlemen in black coats and by the Counsellor's cross of honour, she remained motionless, not knowing whether to advance or retreat, nor why the crowd were pushing her forward or why the judges were smiling at her. There she stood, before these beaming bourgeois, this half-century of servitude.

from *Madame Bovary*,
GUSTAVE FLAUBERT, 1857

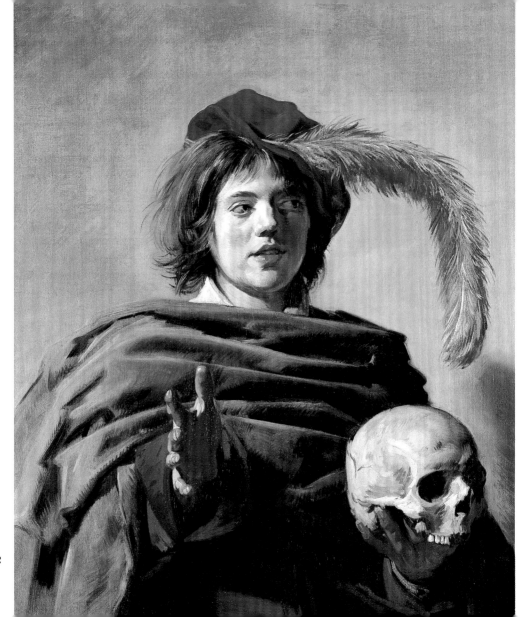

FRANS HALS (1580?–1666) Dutch
Young Man holding a Skull (Vanitas)
1626–28

When first the college rolls receive his name,
The young enthusiast quits his ease for fame;
Through all his veins the fever of renown
Burns from the strong contagion of the gown;
O'er Bodley's dome his future labours spread,
And Bacon's mansion trembles o'er his head.
Are these thy views? proceed, illustrious youth,
And virtue guard thee to the throne of Truth!
Yet should thy soul indulge the gen'rous heat,
Till captive Science yields her last retreat;
Should Reason guide thee with her brightest ray,
And pour on misty Doubt resistless day;
Should no false Kindness lure to loose delight,
Nor Praise relax, nor Difficulty fright;
Should tempting Novelty thy cell refrain,
And Sloth effuse her opiate fumes in vain;
Should Beauty blunt on fops her fatal dart,
Nor claim the triumph of a letter'd heart;
Should no Disease thy torpid veins invade,
Nor Melancholy's phantoms haunt thy shade;
Yet hope not life from grief or danger free,
Nor think the doom of man revers'd for thee:
Deign on the passing world to turn thine eyes,
And pause awhile from letters, to be wise;

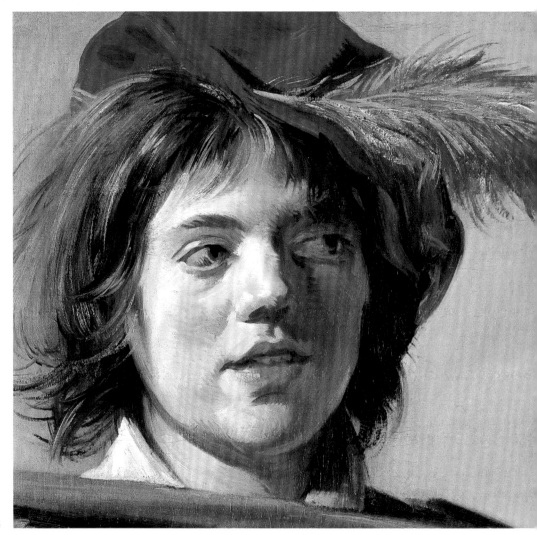

There mark what ills the scholar's life assail,
Toil, envy, want, the patron, and the jail.
See nations slowly wise, and meanly just,
To buried merit raise the tardy bust.
If dreams yet flatter, once again attend,
Hear Lydiat's life, and Galileo's end.

 Nor deem, when learning her last prize bestows,
The glitt'ring eminence exempt from foes;
See when the vulgar 'scape, despis'd or aw'd,
Rebellion's vengeful talons seize on Laud.
From meaner minds, tho' smaller fines content.
The plunder'd palace or sequester'd rent;
Mark'd out by dangerous parts he meets the shock,
And fatal Learning leads him to the block:
Around his tomb let Art and Genius weep,
But hear his death, ye blockheads, hear and sleep.

from *The Vanity of Human Wishes,*
SAMUEL JOHNSON, 1749

Being a barmaid myself for nearly seven years, I speak from
my experience; and what I write I affirm to be the truth.
I live in a city house with six others, and we all work very
hard, our hours being seventeen in a day. We open at 5.30
a.m., and close at 12.30 p.m. (midnight). Two of us take it
in turns to get up for a week at half past five o'clock, and we
retire at 10 p.m. The rest of us get up at 8.00 a.m. and are
up till we close. We are supposed to have two hours rest each
a day, but this we only get three days out of six, and the
other three days we have but an hour.

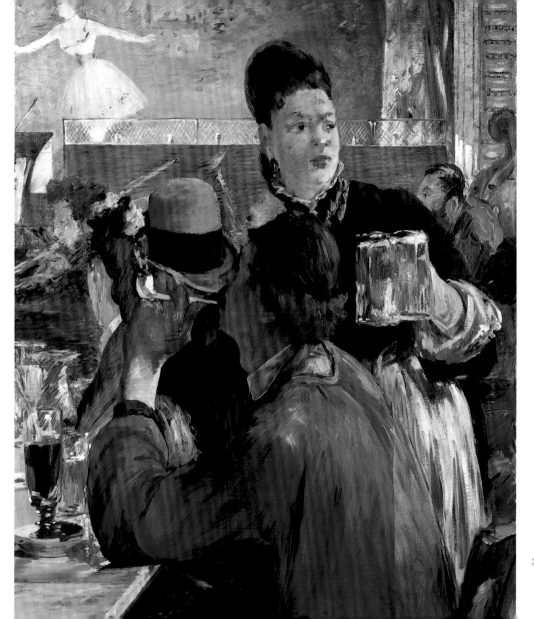

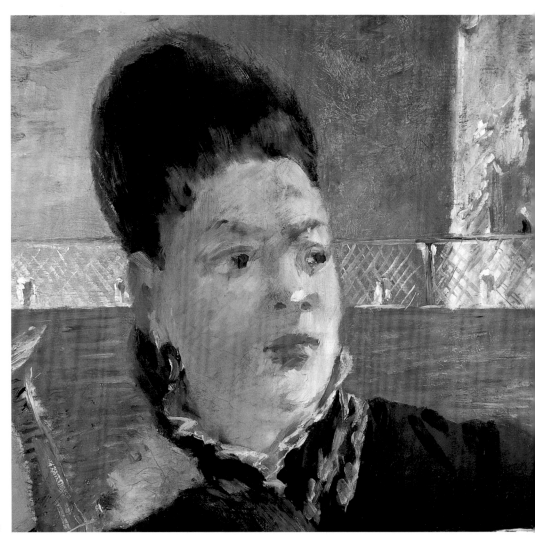

38

We are supposed to be allowed to go out every third Sunday. Several of us have asked to be allowed to go out in rest time to get a breath of fresh air, but we have been refused for fear we should exceed our time. Therefore, from week's end to week's end we have to inhale smoke, gas, and the foul breath of the numbers crowding at our bar, and we have no comfort, release, or relaxation from this dreary, wearing toil. I assure you we all feel fit to drop with fatigue, long before the period comes for our short rest.

from *Victoria Magazine*,
June 1876

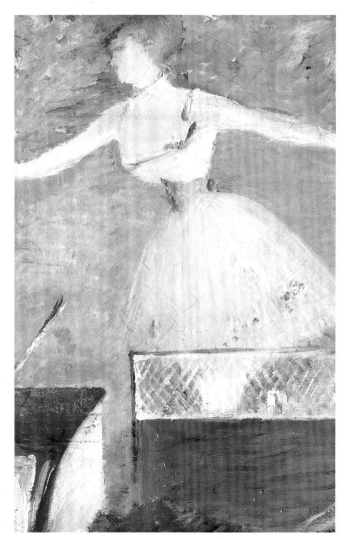

41

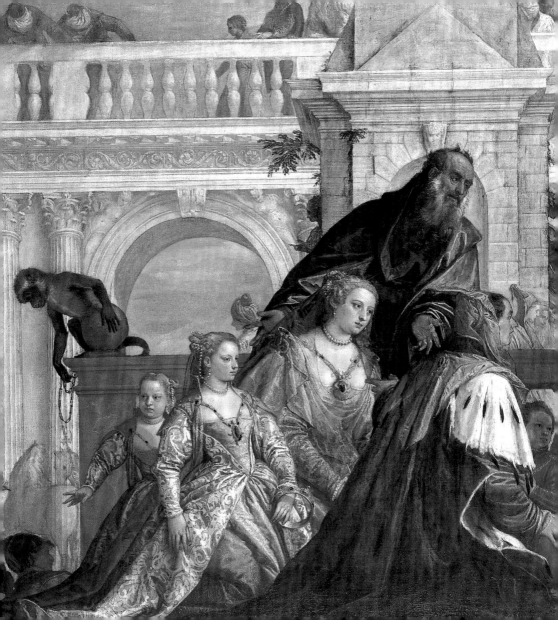

the
celebrated

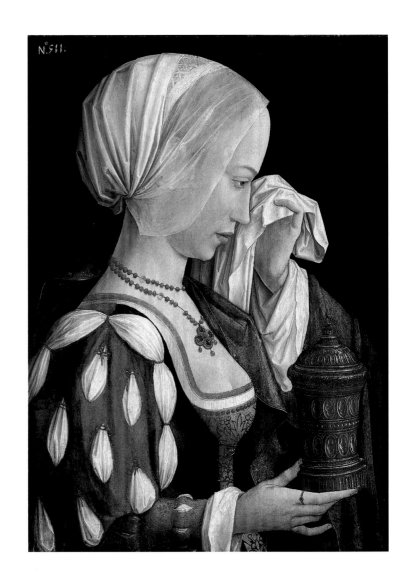

NETHERLANDISH
The Magdalen Weeping
about 1520

I saw my Lady weep,
And Sorrow proud to be advancéd so
In those fair eyes where all perfections keep.
Her face was full of woe,
But such a woe (believe me) as wins more hearts
Than Mirth can do with her enticing parts.

Sorrow was there made fair,
And Passion, wise; Tears, a delightful thing;
Silence, beyond all speech, a wisdom rare:
She made her sighs to sing,
And all things with so sweet a sadness move
As made my heart at once both grieve and love.

O fairer than aught else

The world can show, leave off in time to grieve!

Enough, enough: your joyful look excels:

Tears kill the heart, believe.

O strive not to be excellent in woe,

Which only breeds your beauty's overthrow.

In Lacrimas,
Anonymous, late 16th century

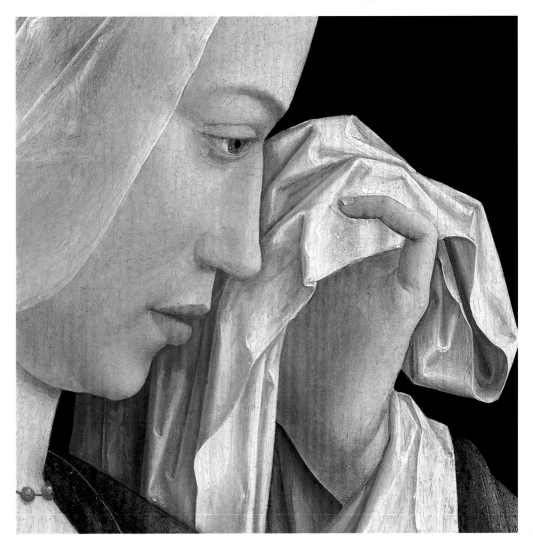

THOMAS GAINSBOROUGH (1727–1788) English
Mrs Siddons
about 1783–85

(Sarah Siddons was a celebrated 18th-century English actress, famous for her performances of tragedy.)
When Mrs Siddons walked off the stage in Her last scene, where she appears as walking in Her sleep, there was a long continued burst of applause, which caused Kemble etc to conclude that it was the wish of the Spectators that the play should there stop. The Curtain was dropped and much noise was continued. One of the Performers came forward to request to know whether it was the pleasure of the audience that the Play should stop or go on.

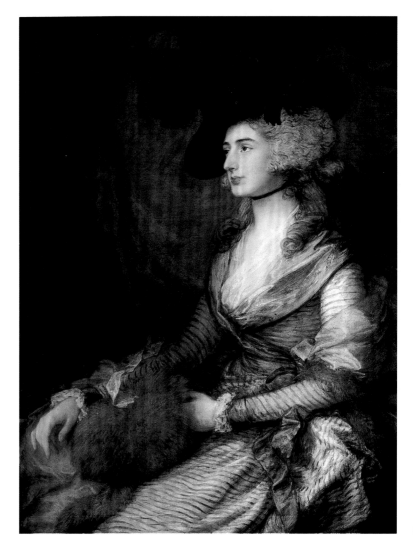

A tumult again ensued, which being considered as a sign that the play should stop, some time elapsed till at length the Curtain was drawn up and Mrs Siddons appeared sitting at a table in Her own character. She was dressed in White Sattin and had on a long veil. She arose but it was some time before she could speak the clapping and other sounds of approbation rendering it impossible for Her to be heard. She curtsied and bowed, and at last there was silence. At 10 o'clock precisely she began to speak Her farewell address which took up Eight minutes during which time there was profound silence. Having finished, the loudest claps followed, and she withdrew bowing and led off by an attendant who advanced for that purpose…Her appearance was that of a person distressed and sunk in spirits, but I did not perceive that she shed tears. J. Kemble came on afterwards to ask 'Whether the Play should go on?' – He wiped His eyes, and appeared to have been weeping – The Play was not allowed to go on.

from *Diary*,
JOSEPH FARINGTON, 29 June 1812

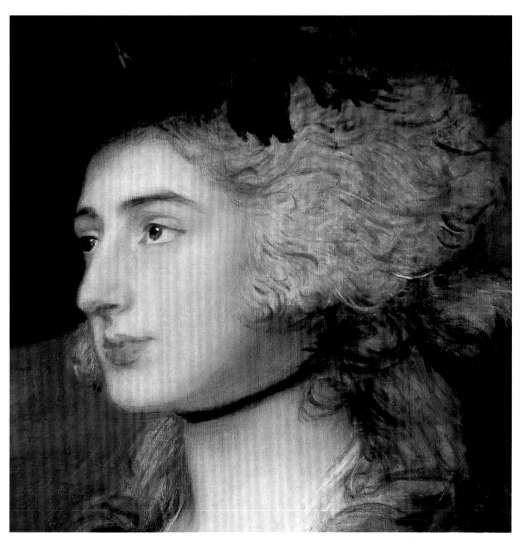

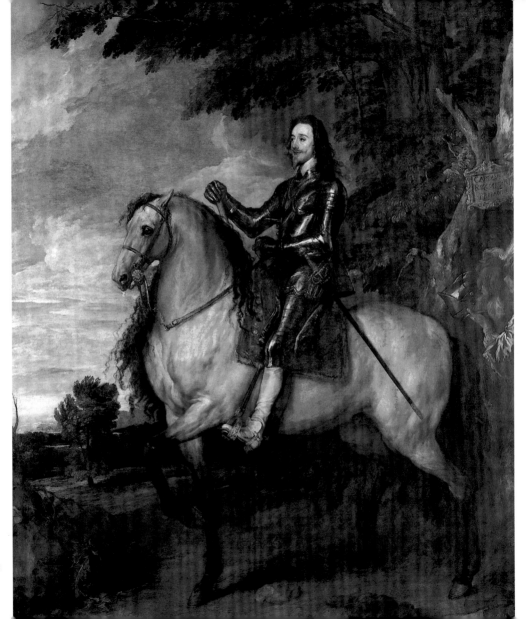

ANTHONY VAN DYCK (1599–1641) Flemish
Equestrian Portrait of Charles I
about 1637–38

King Charles, and who'll do him right now?
King Charles, and who's ripe for fight now?
Give a rouse: here's, in Hell's despite now,
King Charles!

Who gave me the goods that went since?
Who raised me the house that sank once?
Who helped me to gold I spent since?
Who found me in wine you drank once?

To whom used my boy George quaff else,
By the old fool's side that begot him?
For whom did he cheer and laugh else,
While Noll's damned troopers shot him?

King Charles, and who'll do him right now?
King Charles, and who's ripe for fight now?
Give a rouse: here's, in Hell's despite now,
King Charles!

A Cavalier Tune,
ROBERT BROWNING, 1842

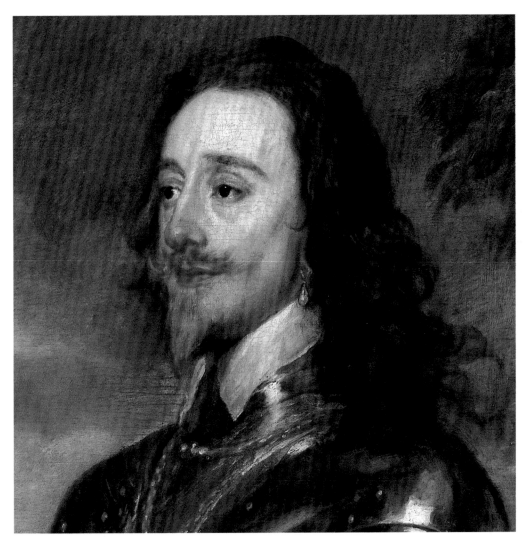

NICOLAS POUSSIN (1594–1665) French
The Triumph of Pan
1636

Night reigned, and his senses were on the alert; he heard
loud confused noises from far away, clamour and hubbub.
There was a rattling, a crashing, a low dull thunder; shrill
halloos and a kind of howl with a long drawn u-sound at the
end. And with all these, dominating them all, flute-notes of
the cruellest sweetness, deep and cooing, keeping shamelessly
on until the listener felt his very entrails bewitched. He
heard a voice, naming, though darkly, that which was to
come: 'The stranger god!' A glow lighted up the surrounding
mist and by it he recognized a mountain scene like that
about his country home. From the wooded heights, from
among the tree trunks and crumbling moss-covered rocks,
a troop came tumbling and raging down, a whirling rout of
men and animals, and overflowed the hillside with flames
and human forms, with clamour and reeling dance. The
females stumbled over the long hairy pelts that dangled from
their girdles; with heads flung back they uttered loud hoarse
cries and shook their tambourines high in the air…Horned
and hairy males, girt about the loins with hides, drooped
heads and lifted arms and thighs in unison, as they beat on
brazen vessels that gave out droning thunder, or thumped
madly on drums.

There were troops of beardless youths armed with
garlanded staves; these ran after goats and thrust their

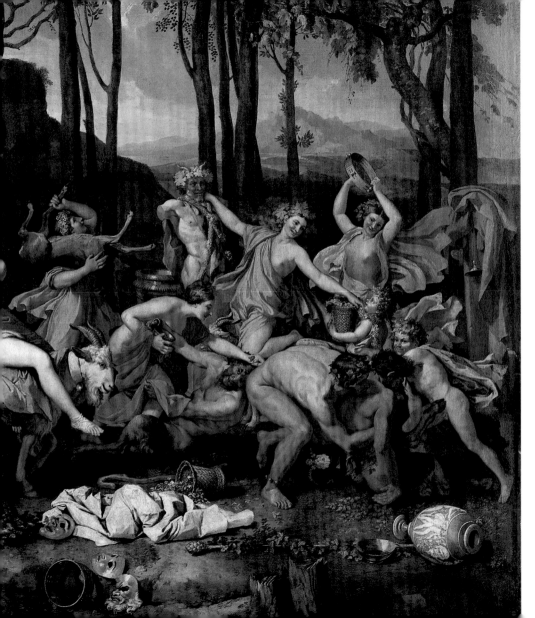

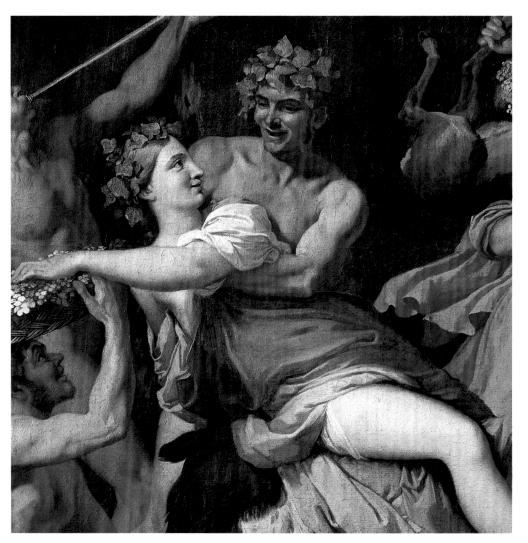

staves against the creatures' flanks, then clung to the plunging horns and let themselves be borne off with triumphant shouts. And one and all the mad rout yelled that cry, composed of soft consonants with a long-drawn u-sound at the end, so sweet and wild it was together, and like nothing ever heard before! It would ring through the air like the bellow of a challenging stag, and be given back many tongued; or they would use it to goad each other on to dance with wild excess of tossing limbs – they never let it die. But the deep beguiling notes of the flute wove in and out and over all.

from *Death in Venice*,
THOMAS MANN, 1912

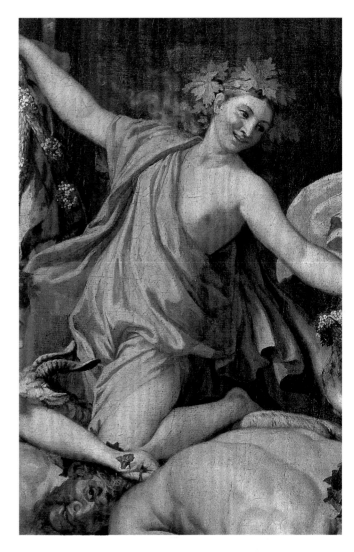

GIOVANNI BATTISTA TIEPOLO (1696–1770) Italian
The Banquet of Cleopatra
1740s

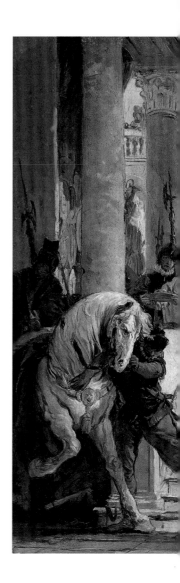

(*Maecenas, Agrippa and Enobarbus in conversation*)
MAE. She's a most triumphant lady, if report be square to
her.

ENO. When she first met Mark Antony, she pursed up his
heart, upon the river of Cydnus.

AGR. There she appeared indeed. Or my reporter devised
well for her.

ENO. I will tell you.
The barge she sat in, like a burnished throne,
Burned on the water. The poop was beaten gold;
Purple the sails, and so perfumèd that
The winds were love-sick with them. The oars
 were silver,
Which to the tunes of flutes kept stroke and made
The water which they beat to follow faster,
As amorous of their strokes. For her own person,

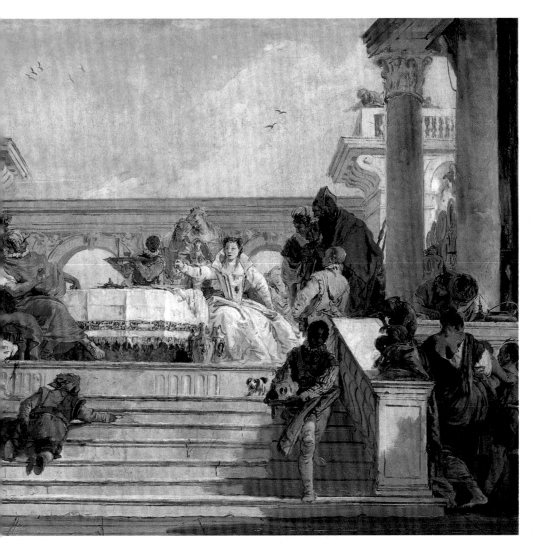

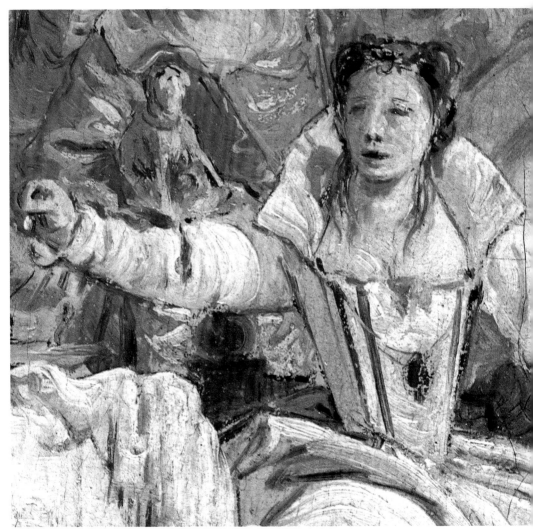

It beggared all description. She did lie
In her pavilion, cloth-of-gold of tissue,
O'erpicturing that Venus where we see
The fancy outwork nature. On each side her
Stood pretty dimpled boys, like smiling cupids,
With divers-coloured fans, whose wind did seem
To glow the delicate cheeks which they did cool,
And what they undid did.

AGR. O, rare for Antony!

ENO. Her gentlewomen, like the Nereides,
So many mermaids, tended her i' th' eyes,
And made their bends adornings. At the helm
A seeming mermaid steers. The silken tackle
Swell with the touches of those flower-soft hands,
That yarely frame the office. From the barge
A strange invisible perfume hits the sense
Of the adjacent wharfs. The city cast
Her people out upon her; and Antony,
Enthroned i' th' market-place did sit alone…

from *Antony and Cleopatra*,
WILLIAM SHAKESPEARE, 1606–07

65

FRANÇOIS-HUBERT DROUAIS (1727–1775) French
Madame de Pompadour
1763–64

Mme de Pompadour had put on some weight and her face was lovelier than ever, that is, full of grace and talent, especially that which fitted her position, so that one felt she was born to it. She took part in many things without appearing to do so, and just as if she were not concerned at all; on the contrary, she pretended, either genuinely or as a matter of policy, to be more interested in her little comedies or in any such trifles than anything else. She teased the King in many ways and used the cleverest gallantry to keep him. During the first years she tried to please everybody in order to turn them to good account, especially those of the highest rank. Then, having a more secure position and knowing her way about, she was a little more confident and less obliging, but she was always quite polite and tried to please or at least to look as if she did.

from *Journal*,
DUC DE CROY, about 1750

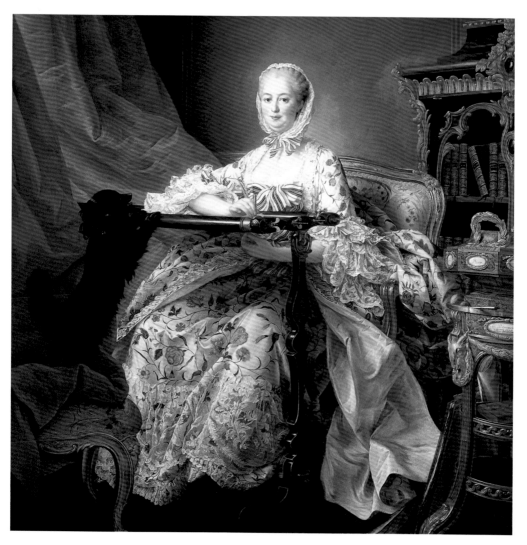

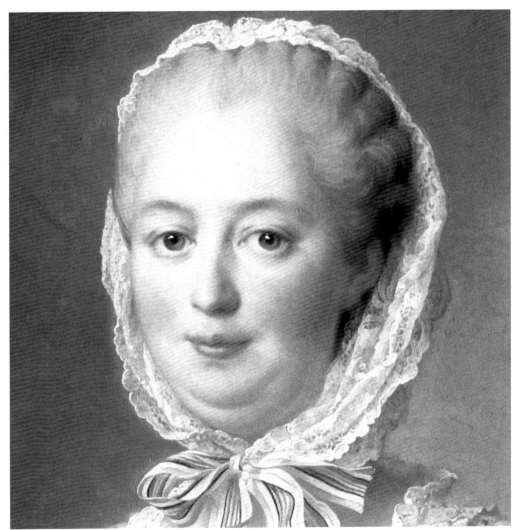

70

FRANCISCO DE GOYA (1746–1828) Spanish
The Duke of Wellington
1812–14

Britannia now lament for our hero that is dead,
That son of Mars, brave Wellington, alas, his spirit's fled.
That general of a hundred fights, to death he had to yield,
Who braved the cannons' frightful blaze upon the battle field.

Britannia weep and mourn, his loss all may deplore,
That conquering hero Wellington, alas, he is no more.

The destructive wars of Europe do not disturb him now,
Great laurels of bright victory sit smiling on his brow,
For the burning sands of India he traced with valour bright,
And against the daring Tippoo Saib so valiant did he fight.

Where cannons loud did rattle, spread death and sad dismay,
The Duke was always ready with his men to lead the way.
Fortified cities he laid low, that general of renown,
Intrenchments and their batteries he quickly levelled down.

Through Portugal and Spain his enemy did pursue,
With the veteran sons of Britain he marched to Waterloo,
And there he made a noble stand upon that blood-stained day,
And fought the French so manfully and made them run away.

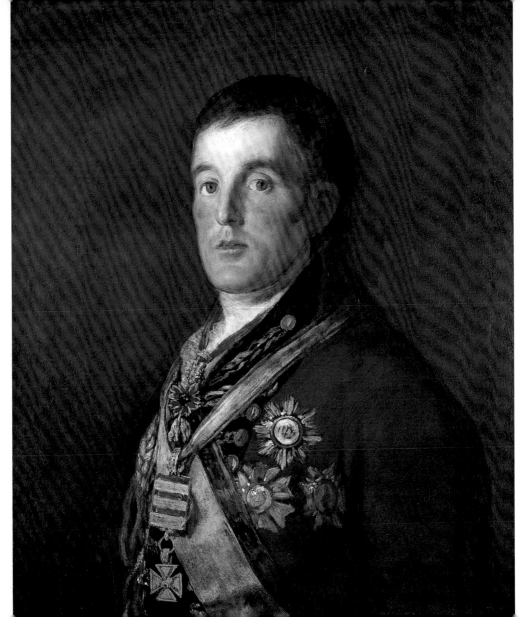

On the plains of Waterloo where thousands they lay dead,
The iron balls in showers flew round his martial head,
While his valiant men and generals lay bleeding in their gore,
The laurels from the French that day brave Wellington he tore.

Napoleon was as brave a man as ever took the field,
And with the warlike sons of France he said he would not yield;
But the reverse of fortune that day did on him frown,
By Wellington and his army his eagles were pulled down.

Now let him rest in peace, and none upbraid his name,
On his military glory there never was a stain;
The steel-clad cuirassiers of France that day at Waterloo,
He quickly made them face about and cut their armour through.

Brave Ponsonby and Picton they fell upon that day,
And many a valiant soldier brave in peace their ashes lay,
And that brave Duke that led them on, his spirit's took its flight;
To see him laid down in his tomb will be a solemn sight.

Lamentation on the Death of the Duke of Wellington,
ANONYMOUS, 1852

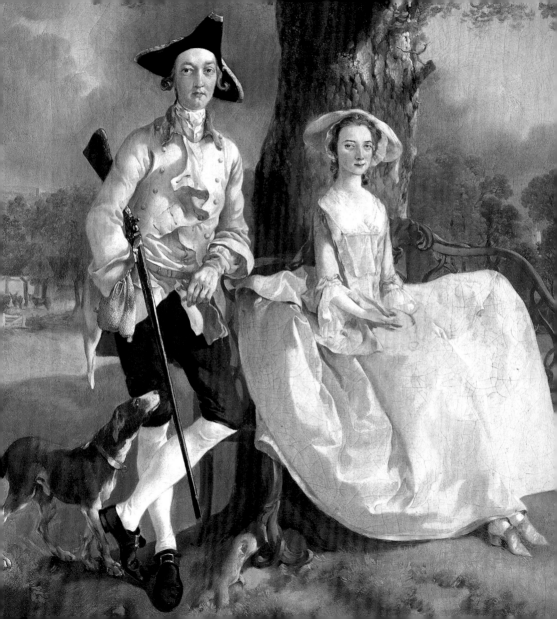

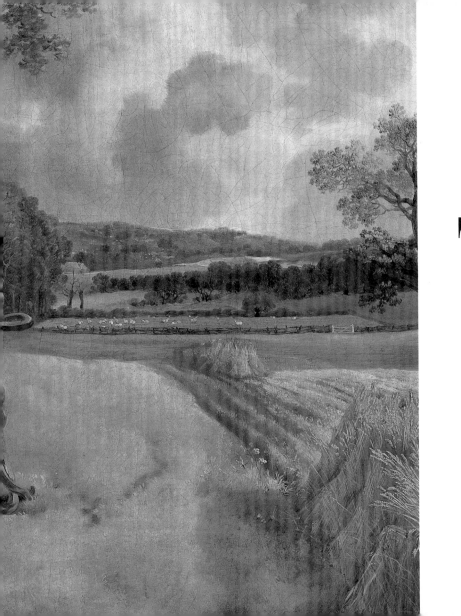

couples

JEAN-ANTOINE WATTEAU (1684–1721) French
The Scale of Love
1715–18

Love in my bosom like a bee
 Doth suck his sweet;
Now with his wings he plays with me,
 Now with his feet.
Within mine eyes he makes his nest,
His bed amidst my tender breast;
My kisses are his daily feast,
And yet he robs me of my rest.
 Ah, wanton, will ye?

And if I sleep, then percheth he
 With pretty flight,
And makes his pillow of my knee
 The livelong night.
Strike I my lute, he tunes the string;
He music plays if so I sing;
He lends me every lovely thing;
Yet cruel he my heart doth sting.
 Whist, wanton, still ye!

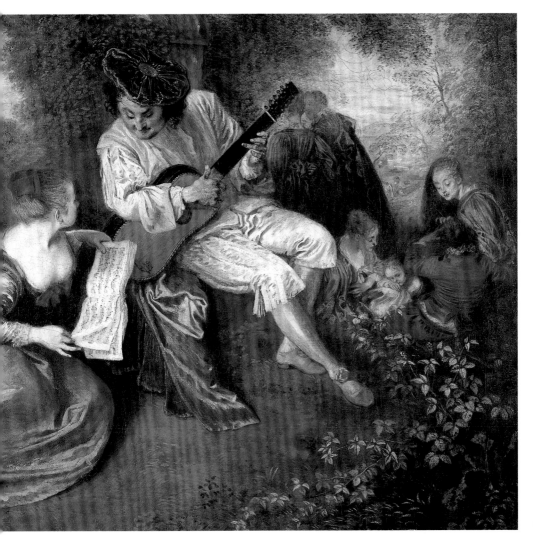

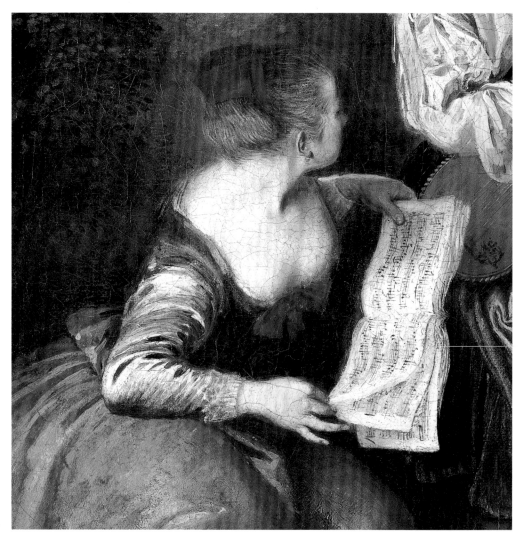

Else I with roses every day
 Will whip you hence
And bind you, when you long to play,
 For your offense.
I'll shut mine eyes to keep you in,
I'll make you fast it for your sin,
I'll count your power not worth a pin.
Alas! what hereby shall I win
 If he gainsay me?

What if I beat the wanton boy
 With many a rod?
He will repay me with annoy,
 Because a god.
Then sit thou safely on my knee,
And let thy bower my bosom be;
Lurk in mine eyes, I like of thee.
O Cupid, so thou pity me,
 Spare not, but play thee!

Rosalind's Madrigal,
THOMAS LODGE, 1590

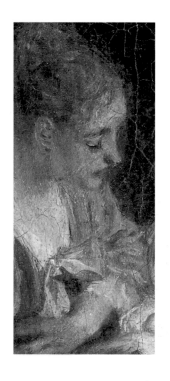

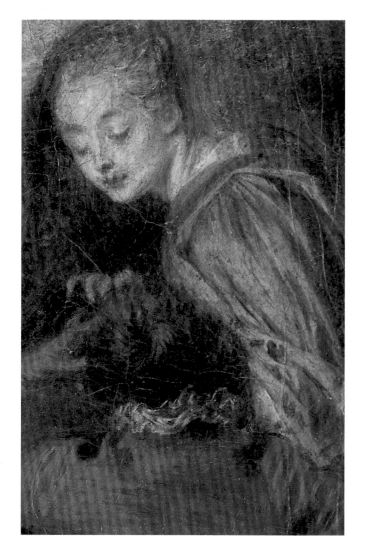

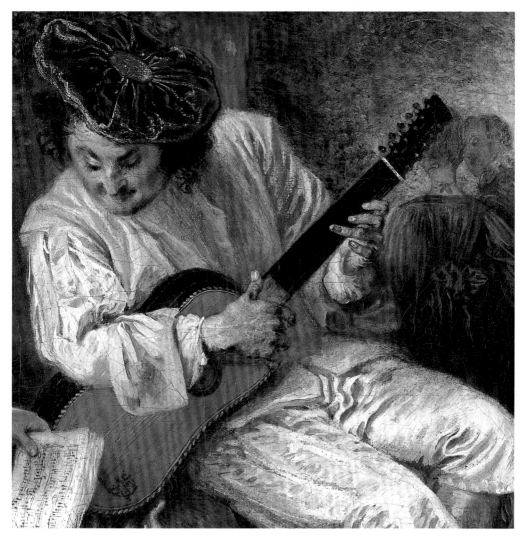

JAN VAN EYCK (active 1422; died 1441) Flemish
The Arnolfini Portrait
1434

Marriage is not a justifiable plea for the refusal of love.

He who cannot keep a secret knows not how to love.

No one can devote himself to two loves.

Love is always either waxing or waning.

There is no true delight to the lover in what the loved one
 yields unwillingly.

A boy seldom loves until he has attained puberty.

If death should take one of the two lovers, then love must be
 forsworn for two years by the lover that lives on.

No lover should be deprived of his privileges except for an
 excellent reason.

Love cannot be unless the persuasion of love itself compel it.

Where avarice keeps house love is in exile.

It is unbefitting to love a woman whom one would scorn to
 marry.

A true love longs for the embrace of the loved one only.

A love made commonplace seldom endures.

Too easy a success in love deprives it of its charm:
 hindrances add to its value.

A lover pales at the sight of his beloved.

He trembles at an unforeseen meeting with her.

A new love banishes the old.

from *The Code of Laws Common to all the Courts of Love in the English,
the French, and the Provençal Dominions of the Twelfth Century*

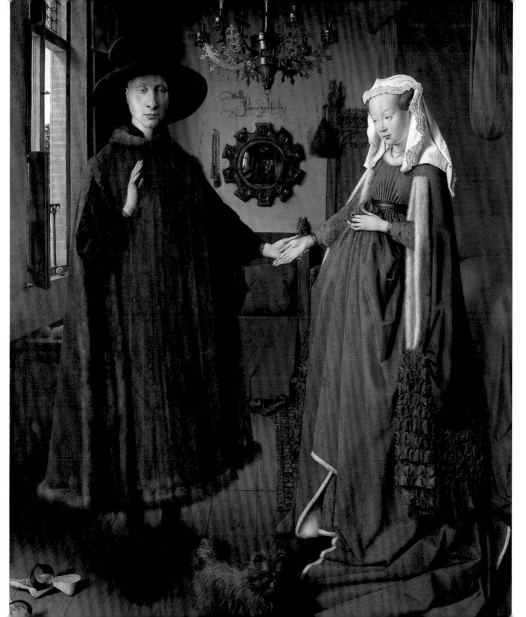

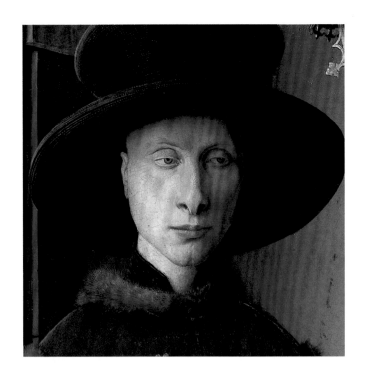

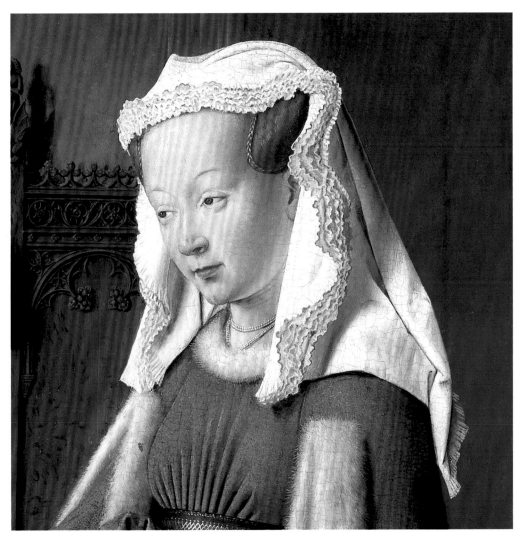

87

SANDRO BOTTICELLI
(about 1445–1510)
Italian
Venus and Mars
about 1485

Being your slave what should I do but tend,
Upon the hours and times of your desire?
I have no precious time at all to spend;
Nor services to do, till you require.
Nor dare I chide the world-without-end hour,
Whilst I (my sovereign) watch the clock for you,
Nor think the bitterness of absence sour,
When you have bid your servant once adieu.

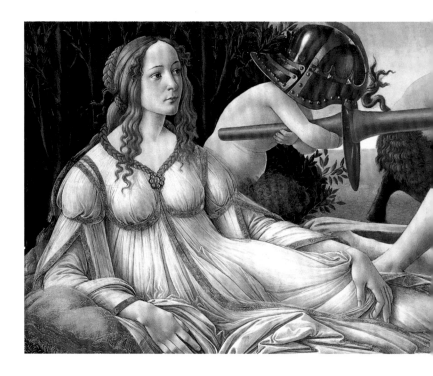

Nor dare I question with my jealous thought,
Where you may be, or your affairs suppose.
But like a sad slave stay and think of nought
Save, where you are, how happy you make those,
 So true a fool is love that in your Will,
 (Though you do any thing) he thinks no ill.

Sonnet LVII,
WILLIAM SHAKESPEARE, 1609

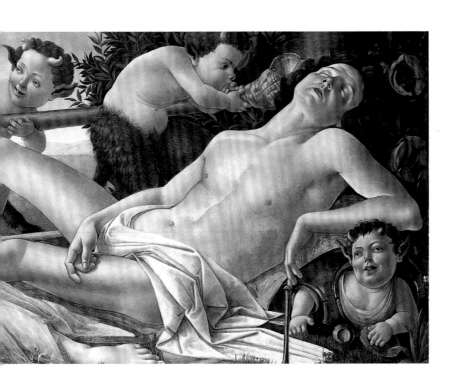

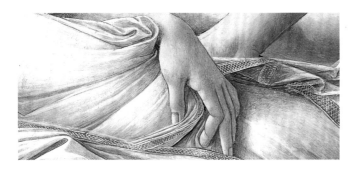

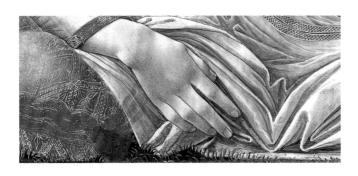

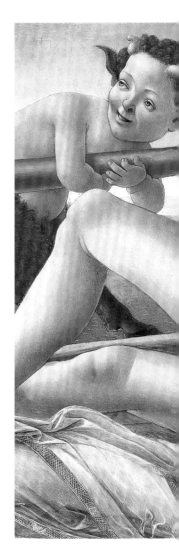

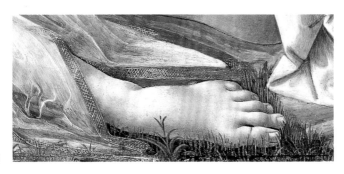

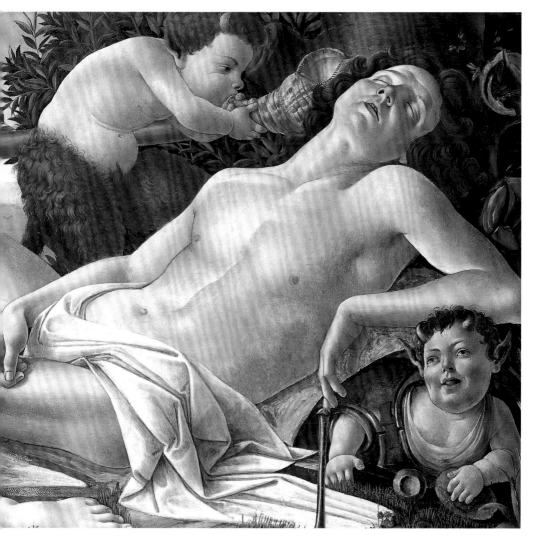

JACOB JORDAENS (1593–1678) Flemish
Portrait of Govaert van Surpele (?) and his Wife
1636–38

Mrs Chub was rich and portly,
 Mrs Chub was very grand,
Mrs Chub was always reckoned
 A lady in the land.

You shall see her marble mansion
 In a very stately square,—
Mr C. knows what it cost him,
 But that's neither here nor there.

Mrs Chub was so sagacious,
 Such a patron of the arts,
And she gave such foreign orders,
 That she won all foreign hearts.

Mrs Chub was always talking,
 When she went away from home,
Of a prodigious painting
 Which had just arrived from Rome.

'Such a treasure,' she insisted,
 'One might never see again!'
'What's the subject?' we enquired.
 'It is Jupiter and Ten!'

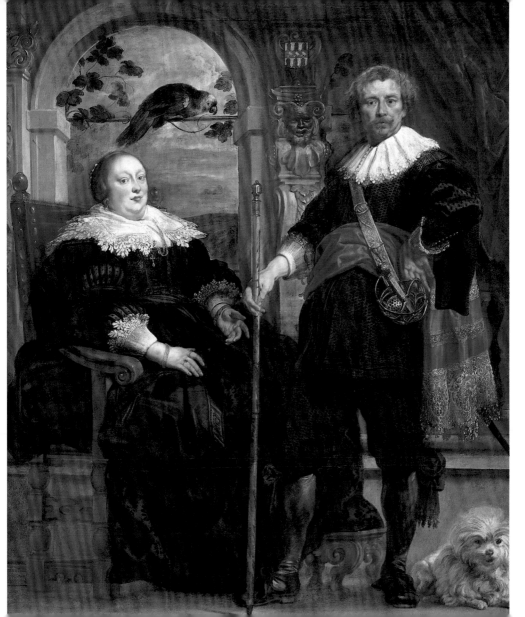

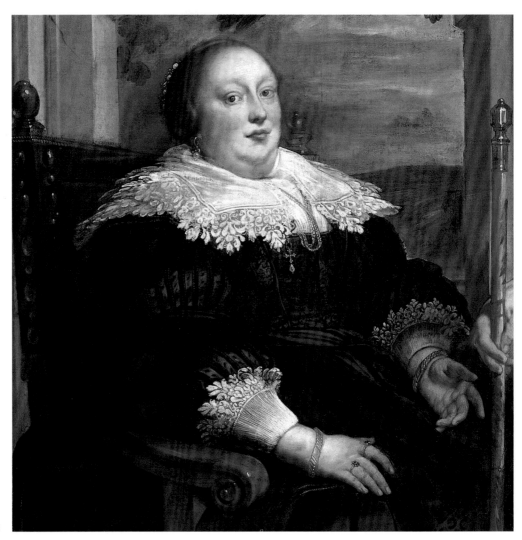

'Ten *what?*' we blandly asked her,
　　For the knowledge we did lack.
'Ah! that I cannot tell you,
　　But the name is on the back.'

'There it stands in printed letters.
　　Come to-morrow, gentlemen,
Come and see our splendid painting,
　　Our fine *Jupiter and Ten.*'

...But when we saw the picture,—
　　Oh, Mrs Chub! Oh, fie! Oh!
We perused the printed label,
　　And 't was *Jupiter and Io!*

from *Jupiter and Ten*,
JAMES THOMAS FIELDS, 19th century

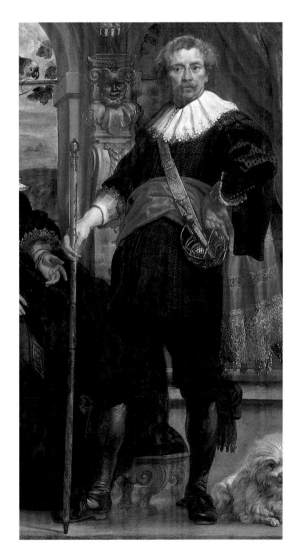

ABRAHAM DE PAPE
(before 1621–1666)
Dutch
Tobit and Anna
about 1658

The old couple were as
absorbed in themselves as
lovers, content and self-
contained; they never left
the village or each other's
company, they lived as
snug as two podded chest-
nuts. By the day blue
smoke curled up from
their chimney, at night the
red windows glowed; the
cottage, when we passed
it, said 'Here live the
Browns', as though that
were part of nature.

Though white and
withered, they were active
enough, but they ordered
their life without haste.
The old woman cooked,
and threw grain to the
chickens, and hung out

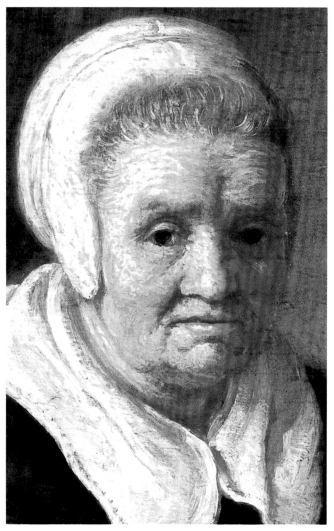

her washing on bushes; the old man fetched wood and chopped it with a billhook, did a bit of gardening now and then, or just sat on a seat outside his door and gazed at the valley, or slept. When summer came they bottled fruit, and when winter came they ate it. They did nothing more than was necessary to live, but did it fondly, with skill – then sat together in their clock-ticking kitchen enjoying their half-century of silence. Whoever called to see them was welcomed gravely, be it man or beast or child; and to me they resembled two tawny insects, slow but deft in their movements; a little foraging, some frugal feeding, then any amount of stillness. They spoke to each other without raised

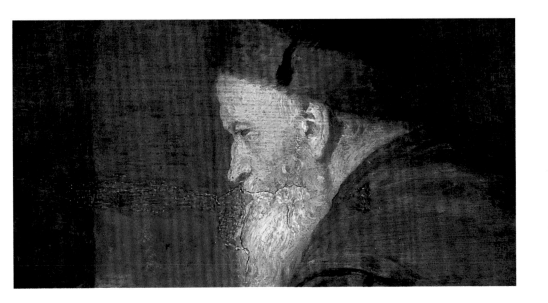

voices, in short chirrups as brief as bird-song, and when they moved about in their tiny kitchen they did so smoothly and blind, gliding on worn, familiar rails, never bumping or obstructing each other. They were fond, pink-faced, and alike as cherries, having taken and merged, through their years together, each other's looks and accents.

It seemed that the old Browns belonged for ever, and that the miracle of their survival was made commonplace by the durability of their love – if one should call it love, such a balance.

from *Cider with Rosie*,
LAURIE LEE, 1959

THOMAS GAINSBOROUGH (1727–1788) English
Mr and Mrs William Hallett ('The Morning Walk')
about 1785

On a summer morning a hundred and fifty years ago a
young Danish squire and his wife went out for a walk on
their land. They had been married a week. It had not been
easy for them to get married, for the wife's family was
higher in rank and wealthier than the husband's...

They were wonderfully happy. The stolen meetings
and secret, tearful love letters were now things of the past.
To God and man they were one; they could walk arm in arm
in broad daylight and drive in the same carriage, and they
would walk and drive so till the end of their days. Their
distant paradise had descended to earth and had proved,
surprisingly, to be filled with the things of everyday life:
with jesting and railleries, with breakfasts and suppers,
with dogs, haymaking and sheep. Sigismund, the young
husband, had promised himself that from now there should
be no stone in his bride's path, nor should any shadow fall
across it. Lovisa, the wife, felt that now, every day and for
the first time in her young life, she moved and breathed in
perfect freedom because she could never have any secret
from her husband.

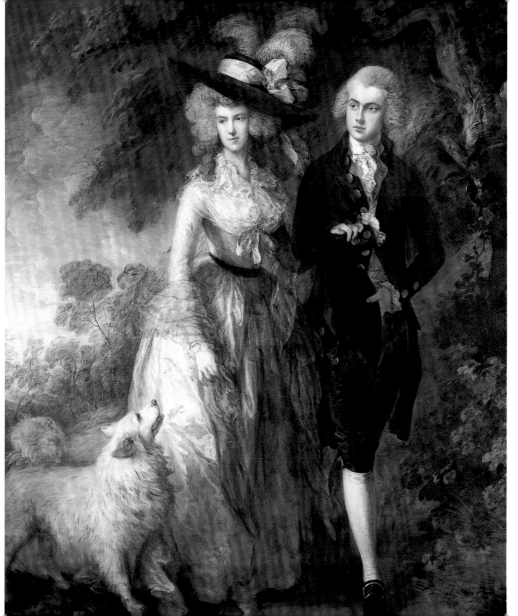

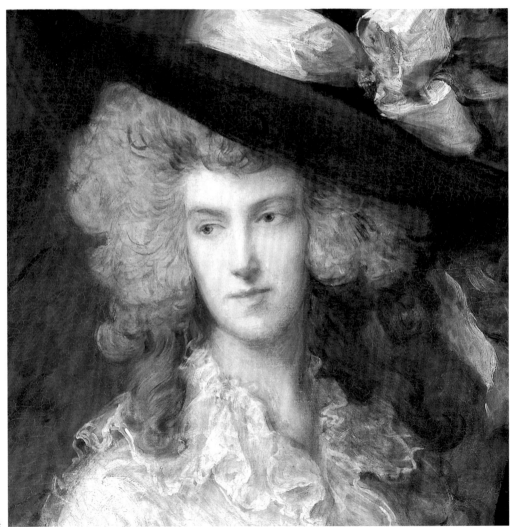

To Lovisa—whom her husband called Lise—the rustic atmosphere of her new life was a matter of wonder and delight. Her husband's fear that the existence he could offer her might not be good enough for her filled her heart with laughter. It was not a long time since she had played with dolls; as now she dressed her own hair, looked over her linen press and arranged her flowers she again lived through an enchanting and cherished experience: one was doing everything gravely and solicitously, and all the time one knew one was playing.

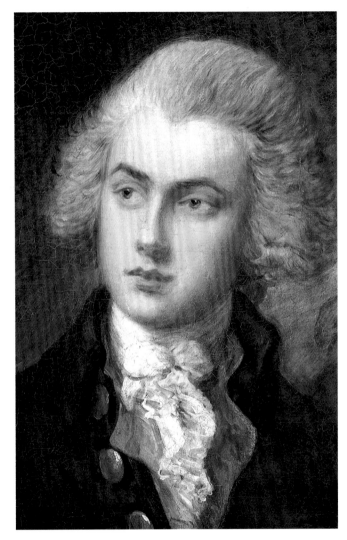

It was a lovely July morning. Little woolly clouds drifted high up in the sky, the air was full of sweet scents. Lise had on a white muslin frock and a large Italian straw hat She and her husband took a path through the park; it wound on across the meadows, between small groves and groups of trees, to the sheep field. Sigismund was going to show his wife his sheep.

from *The Ring*,
ISAK DINESEN, 1958

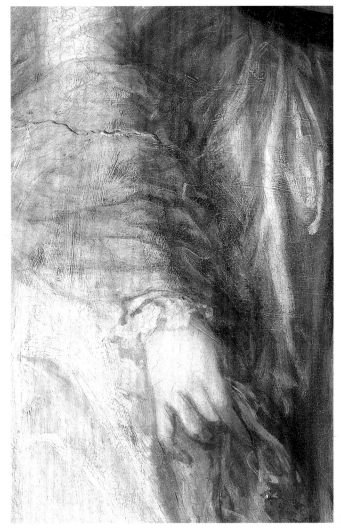

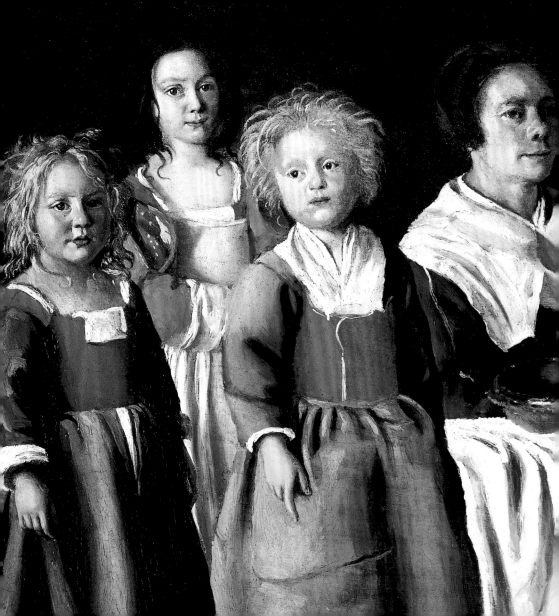

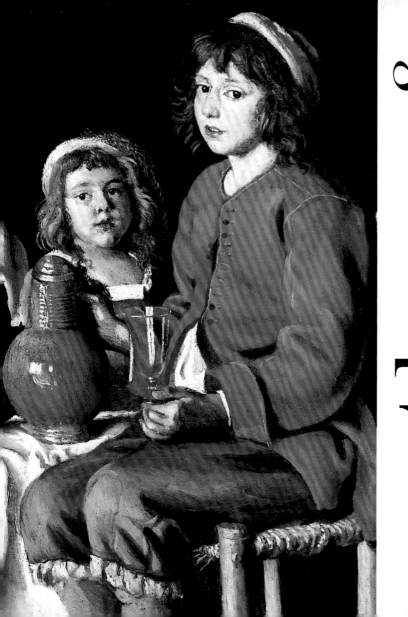

mothers & children

EMANUEL DE WITTE (1615/17–1691/92) Dutch
Adriana van Heusden and her Daughter at the New Fishmarket in Amsterdam
about 1662

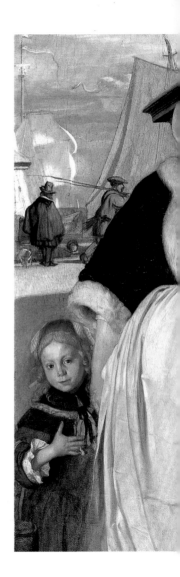

Dear Mama, if you could be
A tiny little girl like me,
And I your mamma, you would see
 How nice I'd be to you.
I'd always let you have your way;
I'd never frown at you and say,
 'You are behaving ill today,
 Such conduct will not do.'

I'd always give you jelly-cake
For breakfast, and I'd never shake
My head, and say, 'You must not take
 So very large a slice.'
I'd never say, 'My dear, I trust
You will not make me say you *must*
Eat up your oatmeal,': or 'The crust
 You'll find it very nice.'

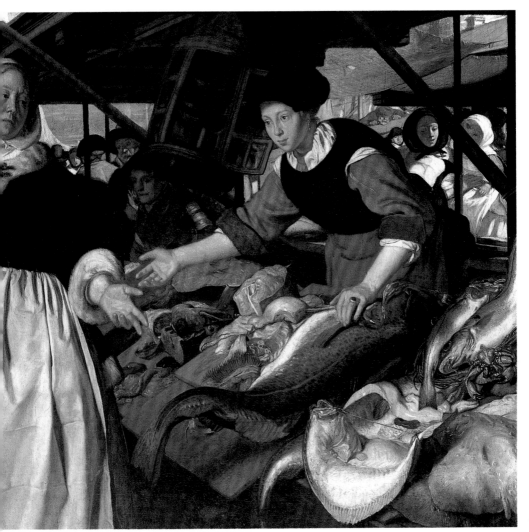

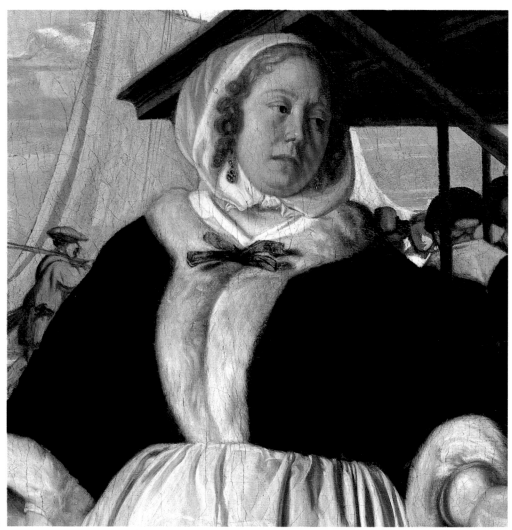

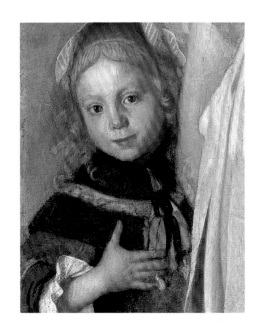

I'd never say, 'Well, just a *few!*'
I'd let you stop your lessons too;
I'd say, 'They are too hard for you
 Poor child to understand.'
I'd put the books and slates away;
You shouldn't do a thing but play,
And have a party every day,
Ah-h-h! wouldn't that be grand!

from *A Lesson for Mama*,
SYDNEY DAYRE (Mrs Cochrane), 1881

(Padovanino, 1588–1648, Italian)
Cornelia and her Sons
17th century

'Later,' his mother said; and still those little hands
Clawed air to clutch the object of their need,
Abandoned as birds to winds or fishes to tide,
Pure time that is timeless, time untenanted.

'Later,' she said; and the word was cold with death,
Opposing space to his time, intersecting his will,
He summoned the cry of a wounded animal,
Mindless Adam whose world lies crushed by the Fall,

But suddenly mended his face and far from tears
Grew radiant, relaxed, letting his hands drop down.
'Later,' he sang, and was human, fallen again,
Received into mind, his dubious, his true demesne.

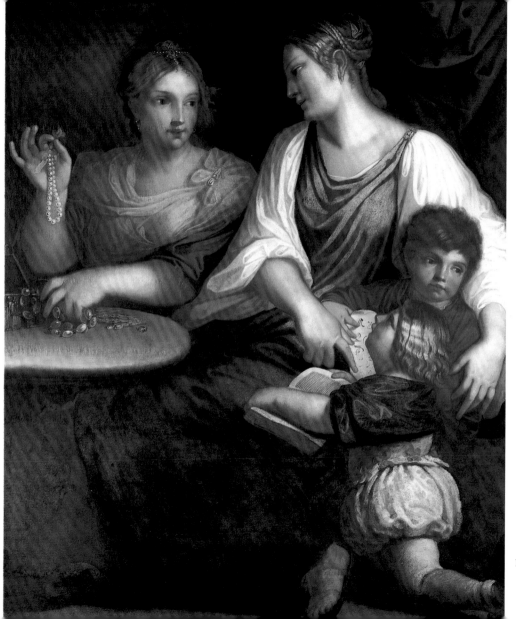

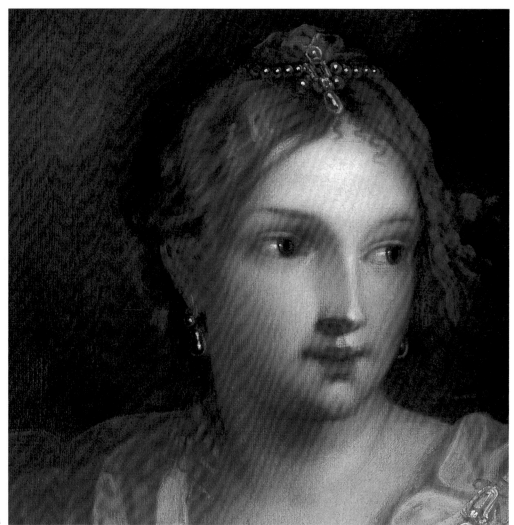

'Later,' he played with the word, and later will envy
The freedom of birds and fishes for ever lost,
When, migrant in mind whom wind and water resist,
Here he must winter in body, bound to the coast;

Or, not all his 'laters' past, perhaps he'll know
That the last releases: reversed, his needs will throng
Homewards to nest in his head and breed among
Those hidden rocks that wrecked him into song.

A Child Accepts,
MICHAEL HAMBURGER, 1953

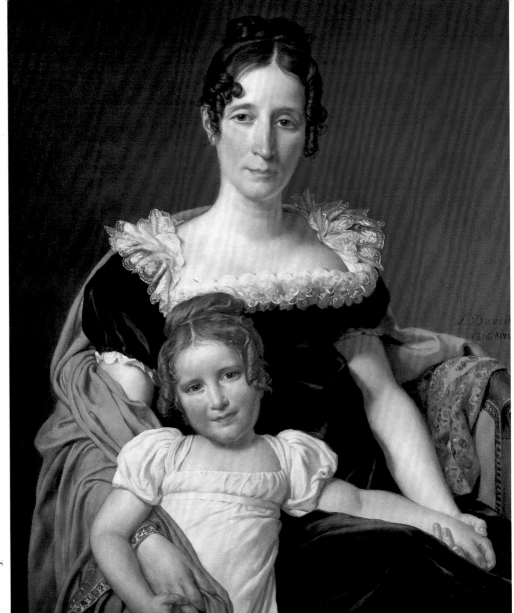

JACQUES-LOUIS DAVID (1748–1825) French
Portrait of the Vicomtesse Vilain XIIII and her Daughter
1816

Child of My Love, 'lean hard,'
And let Me feel the pressure of thy care.
I know thy burden, child: I shaped it,
Poised it in Mine own hand, made no proportion
Of its weight to thine unaided strength;

For even as I laid it on I said –
I shall be near, and while she leans on Me,
This burden shall be Mine, not hers;
So shall I keep My child within the circling arms
Of Mine own love. Here lay it down, nor fear
To impose it on a shoulder which upholds
The government of the worlds. Yet closer come,
Thou art not near enough; I would embrace thy care,
So I might feel My child reposing on my breast.
Thou lovest Me? I know it. Doubt not then,
But, loving Me, lean hard.

Lean Hard
CHARLOTTE BICKERSTETH WARD

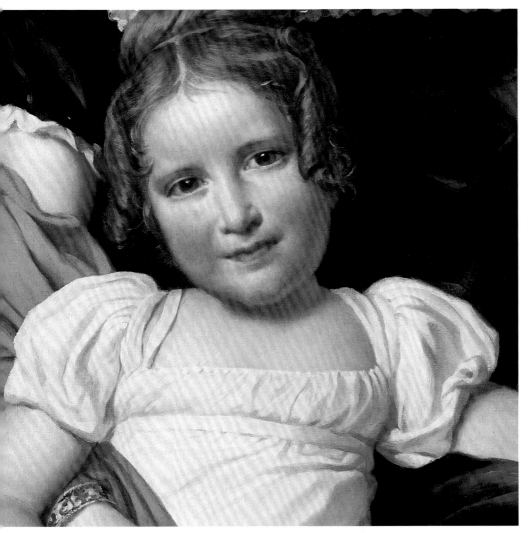

SIR JOSHUA REYNOLDS (1723–1792) English
Lady Cockburn and Her Three Eldest Sons
1773

And a woman who held a babe against her bosom said,
 Speak to us of Children.
And he said:
Your children are not your children.
They are the sons and daughters of Life's longing for itself.
They come through you but not from you.
And though they are with you yet they belong not to you.

You may give them your love but not your thoughts,
For they have their own thoughts.
You may house their bodies but not their souls,
For their souls dwell in the house of tomorrow, which you
 cannot visit, even in your dreams.
You may strive to be like them, but seek not to make them
 like you.
For life goes not backward nor tarries with yesterday.

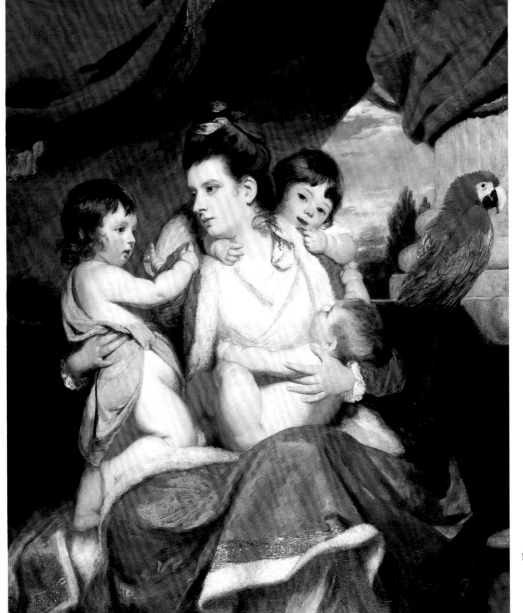

123

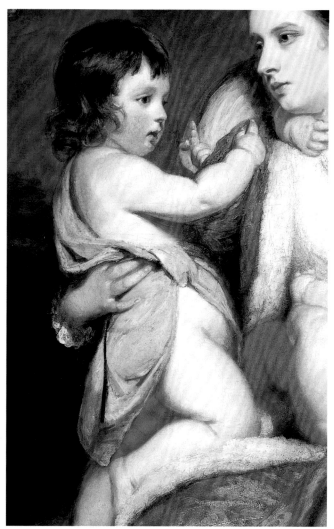

You are the bows from which your children as living arrows
 are sent forth.
The archer sees the mark upon the path of the infinite,
 and He bends you with His might that His arrows may
 go swift and far.
Let your bending in the Archer's hand be for gladness;
For even as He loves the arrow that flies, so He loves also
 the bow that is stable.

from *The Prophet,*
KAHLIL GIBRAN, 1923

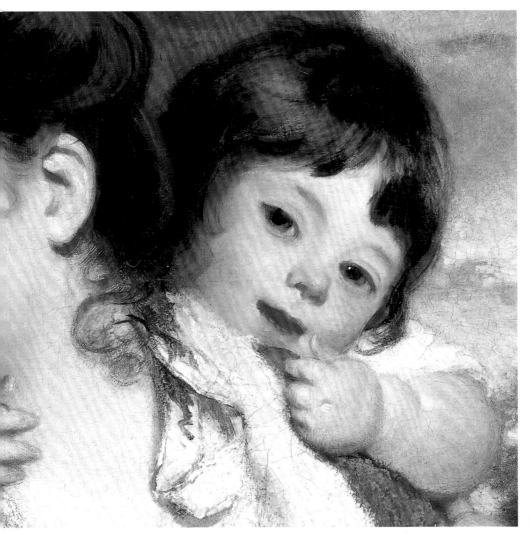

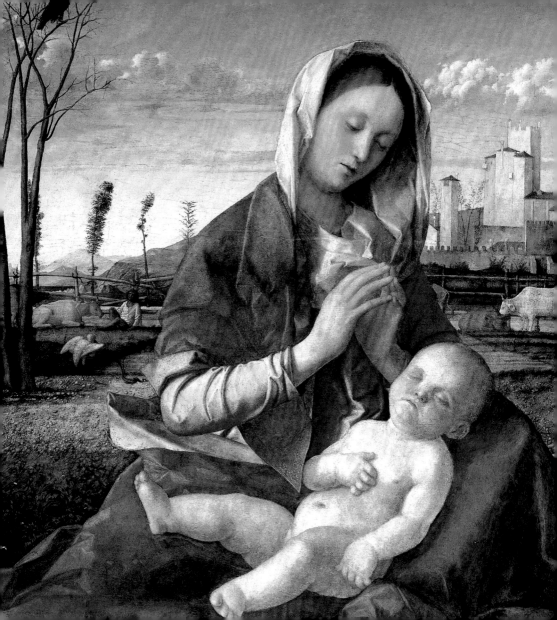

GIOVANNI BELLINI
(active about 1459; died 1516) Italian
The Madonna of the Meadow
about 1500

I sing of a maiden
 That is matchless.
King of all kings
 For her son she chose.

He came all so still
 Where his mother was,
As dew in April
 That falleth on the grass.

He came all so still
 To his mother's bower,
As dew in April
 That falleth on the flower.

He came all so still—
　There his mother lay,
As dew in April
　That falleth on the spray.

Mother and maiden
　Was never none but she;
Well may such a lady
　God's mother be.

Mother and Maiden.
ANONYMOUS, about 1500

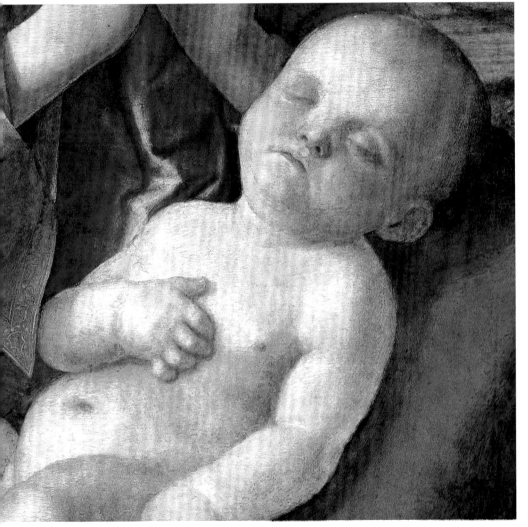

EDOUARD VUILLARD (1868–1940) French
Madame André Wormser and her Children
1926–27

Four heads in one lamp's light
And each head bowed into peculiar darkness,
Reading, drawing, alone.
A camera would have caught them, held them there
Half-lit in the room's warm halflight,
Left them, refused to tell
How long till that lamp was broken,
Your hair pinned up or cut or tinted or waved.

I cannot even describe them, caught no more
Than a flash of light that ripped open
The walls of our half-lit room;
Or the negative—a black wedge
Rammed into light so white that it hurt to look.

Leave this page blank.
You'd neither like nor believe
The picture no lens could have taken:
Tied to my rooted bones
In your chairs you were flying, flying.

For a Family Album,
MICHAEL HAMBURGER, 1964

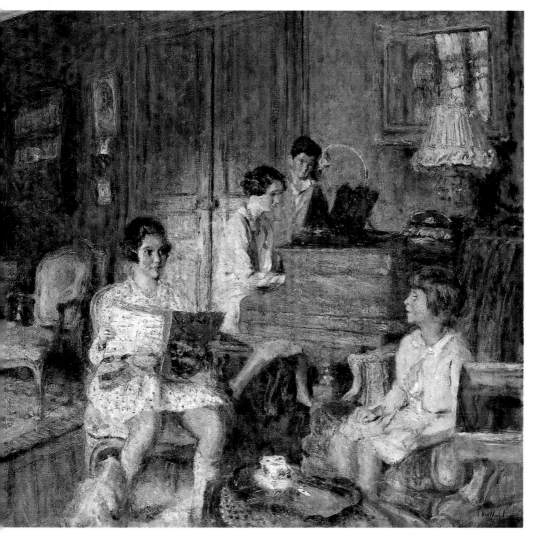

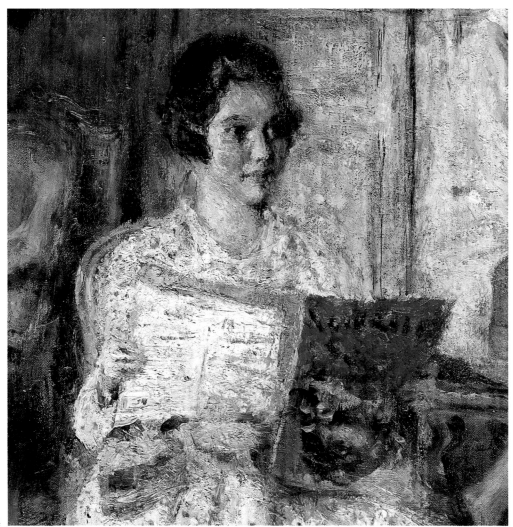

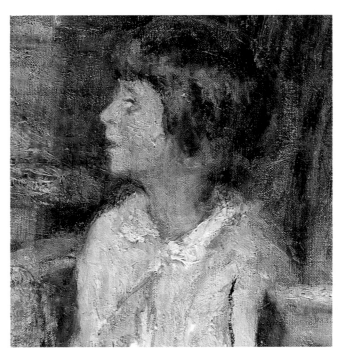

135

The Marquise de Seignelay and Two of her Children

...the shipowner and his wife had taken unto them an *amoretto*. He carried wings into the house, and was in league with the sweet and merciless powers of nature, and his relation to each individual member of the household became a kind of airy love-affair...

Emilie sadly reflected that she was the only person in the house who did not love the child. She felt unsafe with him, even when she was unconditionally accepted as the beautiful, perfect mother, and as she recalled how, only a short time ago, she had planned to bring up the boy in her own spirit, and had written down little memorandums upon education, she saw herself as a figure of fun. To make up for her lack of feeling, she took Jens with her on walks and drives, to the parks and the Zoo, brushed his thick hair and had him dressed up as neatly as a doll. They were always together. She was sometimes amused by his strange, graceful, dignified delight in all that she showed him, and at the next moment, as in Madam Mahler's room, she realised that however generous she would be to him, he would always be the giver. Her sisters-in-law, and her young married friends, fine ladies of Copenhagen with broods of their own, wondered at her absorption in the foundling – and then it happened, when they were off their guard, that they themselves received a dainty arrow in their satin bosoms, and between

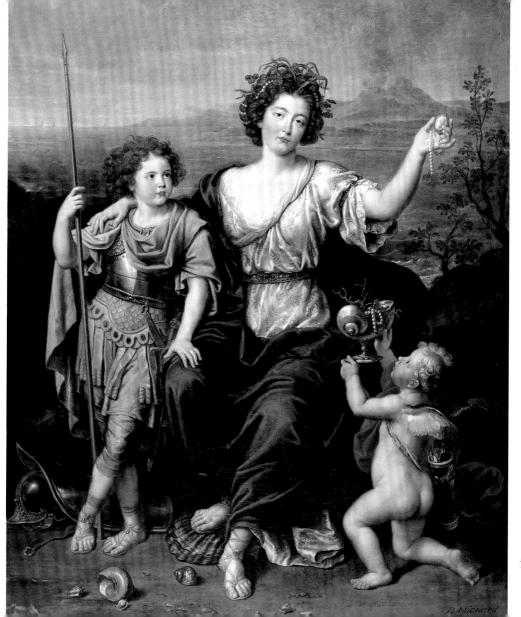

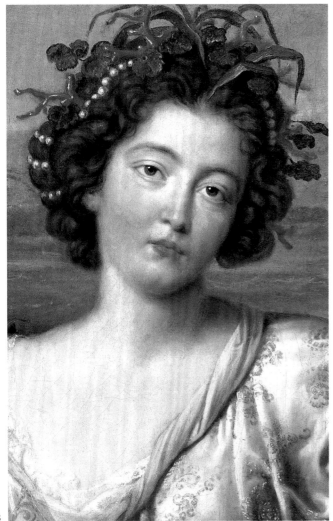

them began to discuss Emilie's pretty boy, with a tender raillery as that with which they would have discussed Cupid.

from *The Dreaming Child*,
ISAK DINESEN, 1943

Artists & Paintings

BELLINI, Giovanni
The Madonna of the Meadow,
oil and egg (identified) on
synthetic panel, transferred
from wood,
67.3 x 86.4 cm, p.128

BOL, Ferdinand
An Astronomer,
oil on canvas,
127 x 135 cm, p.19

BOTTICELLI, Sandro
Venus and Mars,
tempera and oil on poplar,
painted surface
69.2 x 173.4 cm, p.88

CÉZANNE, Paul
*An Old Woman with a
Rosary,*
oil on canvas,
80.6 x 65.5 cm, p.29

CHARDIN, Jean-Siméon
The Young Schoolmistress,
oil (identified) on canvas,
61.6 x 66.7 cm, p.10

DAVID, Jacques-Louis
*Portrait of the Vicomtesse
Vilain XIIII and her
Daughter,* oil on canvas,
95 x 76 cm, p.118

DROUAIS, François-Hubert
Madame de Pompadour,
oil (identified) on canvas,
217 x 156.8 cm, p.67

DYCK, Anthony van
*Equestrian Portrait
of Charles I,*
oil on canvas,
367 x 292.1 cm, p.52

EYCK, Jan van
The Arnolfini Portrait,
oil on oak,
81.8 x 59.7 cm, p.85

GAINSBOROUGH, Thomas
Mr and Mrs Andrews,
oil on canvas,
69.8 x 119.4 cm, p76

Mrs Siddons,
oil (identified) on canvas,
126.4 x 99.7 cm, p.49

*Mr and Mrs William Hallett
('The Morning Walk'),*
oil on canvas,
236.2 x 179.1 cm, p.103

GOYA, Francisco de
The Duke of Wellington,
oil on mahogany,
64.3 x 52.4 cm, p.73

HALS, Frans
*Young Man Holding a Skull
(Vanitas),*
oil on canvas,
92.2 x 88 cm, p.32

HOGARTH, William
*Marriage À-la-Mode:1,
The Marriage Contract,*
oil on canvas,
69.9 x 90.8 cm, p.2

JORDAENS, Jacob
*Portrait of Govaert van
Surpele (?) and his Wife,*
oil on canvas,
213.3 x 189 cm, p.95

LE NAIN BROTHERS
A Woman and Five Children,
oil on copper,
25.5 x 32 cm, p.108

MANET, Edouard
Corner of a Café-Concert,
oil (identified) on canvas,
97.1 x 77.5 cm, p.37

MARINUS van Reymerswaele,
Two Tax Gatherers,
oil on oak,
92.1 x 74.3 cm, p.22

MIGNARD, Pierre
The Marquise de Seignelay and Two of her Children,
oil on canvas,
194.3 x 154.9 cm, p.137

NETHERLANDISH
The Magdalen Weeping,
oil on oak,
52.1 x 38.1 cm, p.44

PADOVANINO
After, *Cornelia and her Sons,*
oil on canvas,
142.5 x 118.1 cm, p.115

PAPE, Abraham de
Tobit and Anna,
oil on oak,
40.7 x 56 cm, p.99

POUSSIN, Nicolas
The Triumph of Pan,
oil (identified) on canvas,
134 x 145 cm, p.57

REYNOLDS, Sir Joshua
Lady Cockburn and her Three Eldest Sons,
oil (identified) on canvas,
141.6 x 113 cm, p.123

SAINT-AUBIN,
Gabriel-Jaques de
A Street Show in Paris,
oil on canvas,
80 x 64.1 cm, p.14

STEEN, Jan
Skittle Players outside an Inn,
oil on oak,
33.5 x 27 cm, p.8

TIEPOLO, Giovanni Battista
The Banquet of Cleopatra,
oil on canvas,
46.3 x 66.7 cm, p.61

VERONESE, Paolo
The Family of Darius before Alexander,
oil (identified) on canvas,
236.2 x 474.9 cm, p.42

VUILLARD, Edouard
Madame André Wormser and her Children,
oil on canvas,
89 x 116.5 cm, p.133

WATTEAU, Jean-Antoine
The Scale of Love,
oil on canvas,
50.8 x 59.7 cm, p.79

WITTE, Emanuel de
Adriana van Heusden and her Daughter at the New Fishmarket in Amsterdam,
oil on canvas,
57.1 x 64.1 cm, p.111

WRITERS & WORKS

Acknowledgments

The editor and publishers gratefully acknowledge permission to reprint copyright material below. Every effort has been made to contact the original copyright holders of the materials included. Any omissions will be rectified in future editions.

excerpt from *The Dreaming Child* from 'Winter's Tales' by Isak Dinesen. Copyright © 1942 by Random House, Inc. Copyright reviewed 1970 by Johan Philip Thomas Ingerslev c/- The Rungstedlund Foundation. Reprinted by permission of Random House, Inc.

A Child Accepts by Michael Hamburger from 'Collected Poems 1941–1994' published by Anvil Press Poetry, 1995 by permission of the author and publisher.

For a Family Album by Michael Hamburger from 'Collected Poems 1941–1994' published by Anvil Press Poetry, 1995 by permission of the author and publisher.

excerpt from *Cider with Rosie* by Laurie Lee, published by Hogarth Press by kind permission of Random House UK Limited.

excerpt from *Death in Venice* by Thomas Mann, translated by H. T. Porter-Lowe. Copright © 1930, 1931, 1936 by Alfred A. Knopf, Inc. Reprinted by permission of Alfred A. Knopf, Inc.

Sandro Botticelli: detail of *Venus and Mars*

Title page: William Hogarth,
 *Marriage À-la-Mode: 1,
 The Marriage Contract*,
 before 1743
Everyman & Everywoman
 title page: Jan Steen,
 *Skittle Players outside an
 Inn*, probably 1660–63
The Celebrated title page:
 Paolo Veronese, *The
 Family of Darius before
 Alexander*, 1565–70
Couples title page: Thomas
 Gainsborough, *Mr and Mrs
 Andrews*, about 1748–49
Mothers & Children title
 page: Le Nain Brothers,
 *A Woman and Five
 Children*, 1642